Kyler

Boudreau

MICKEY'S DRAWING CLASS

Featuring

PLUTO

With step by step method
developed by

LEE J. AMES

A Little Simon Book
Published by Simon & Schuster

Copyright © 1983 by Walt Disney Productions. All rights reserved. Published by Little Simon, A Simon & Schuster Division of Gulf & Western Corporation. Simon & Schuster Building, 1230 Avenue of the Americas, New York, New York 10020.

Little Simon and colophon are trademarks of Simon & Schuster. Printed in U.S.A.

10 9 8 7 6 5 4 3 2 1

ISBN 0-671-44496-4

Contents

The Equipment You'll Need

The equipment that you will need is inexpensive and easy to find. First, you will need a handful of well sharpened #2 pencils with soft erasers. Second, get yourself a good grade of crayon pencil—two or three will do—well sharpened and of any middle value color. Middle value means not too light and not too dark. Third, you will need a stack of sheets of 8½ by 11-inch bond paper or typewriter paper.

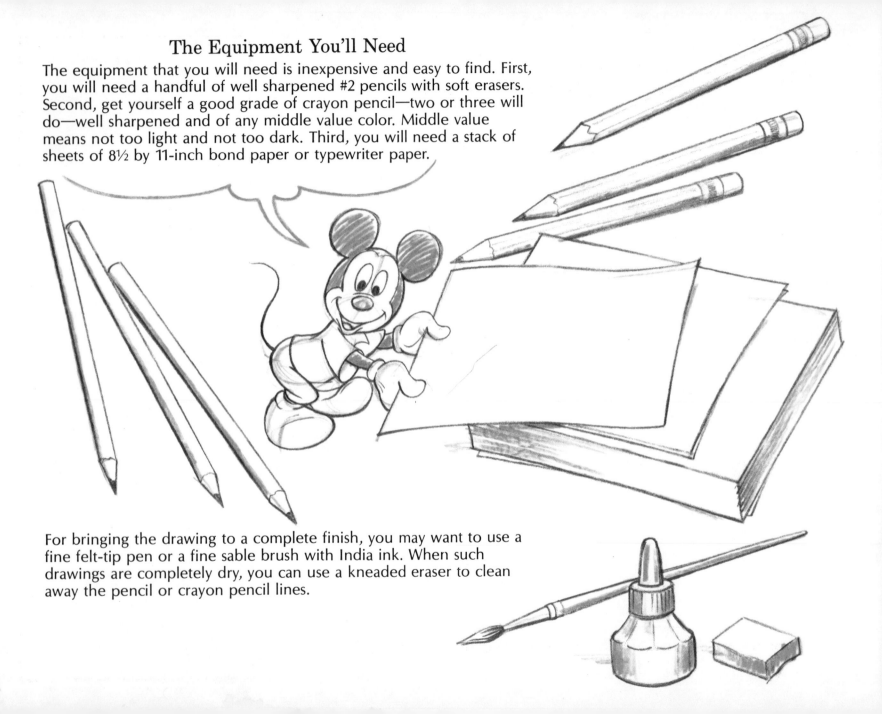

For bringing the drawing to a complete finish, you may want to use a fine felt-tip pen or a fine sable brush with India ink. When such drawings are completely dry, you can use a kneaded eraser to clean away the pencil or crayon pencil lines.

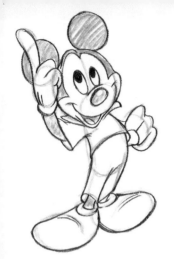

Tips From Mickey

Before you start your drawing, locate the general area of your picture, either by eye or with a very light line. You do this in order to avoid making the finished picture ...

... too tiny with lots of empty wasted space around it.

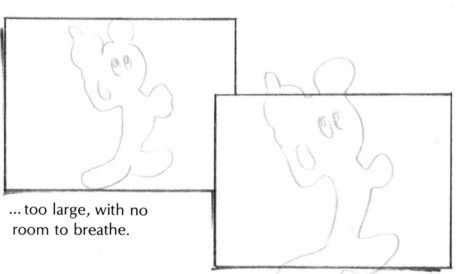

... too large, with no room to breathe.

...so large that it will not even fit on the paper.

...too far off in one direction or another so that everything seems unbalanced.

So before you begin, locate your picture comfortably on the page.

A Good Rule

When beginning your picture, always start very lightly, using your pencil or your crayon pencil. Keep building up light drawing over light drawing, erasing if necessary, until somewhere amongst all these light lines you can find exactly the right one to use in the final drawing.

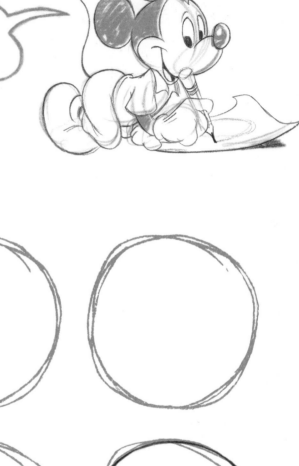

A Solid Thought

In sketching the simple shapes you need to make your picture, think of them as solid objects. For example, instead of thinking of a circle, think of a ball. Instead of an oval, you might thing of an egg, a grape, a bean, and so on. As you draw you should feel as though you are modeling the shape in clay.

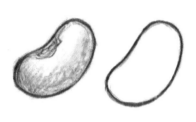
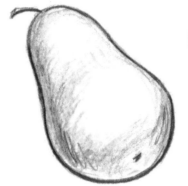

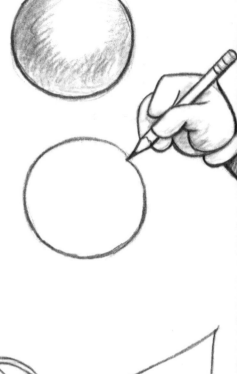

Also!

After you've been at it for a while, but well before you've finished whatever you may be drawing, I suggest that you try holding your work up to a mirror. Sometimes the mirror shows you unexpected twists and flaws that you can then correct.

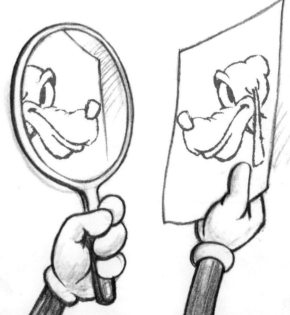

9

Warming Up With Mickey

Before you start, it's worthwhile spending a few
minutes warming up...

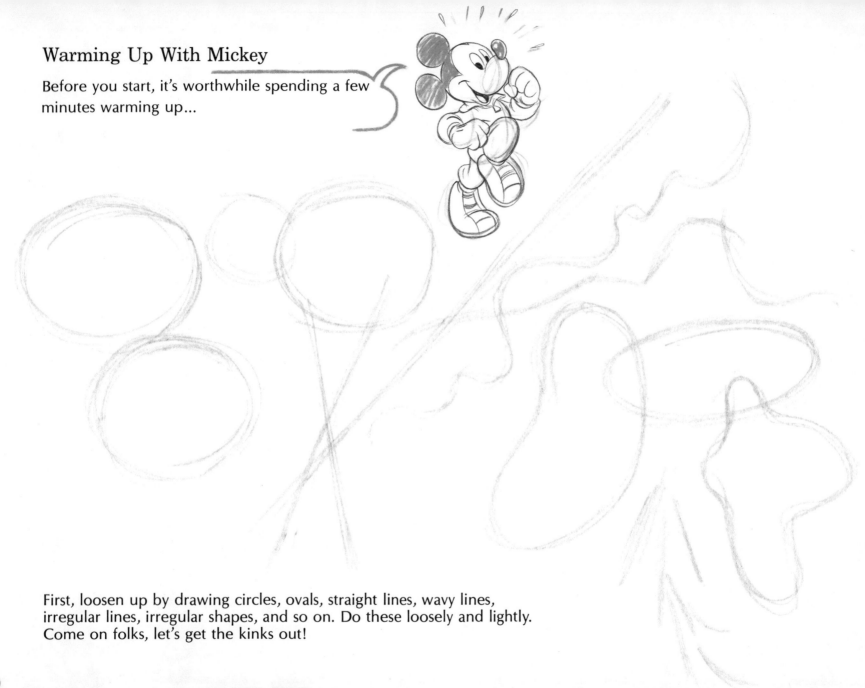

First, loosen up by drawing circles, ovals, straight lines, wavy lines,
irregular lines, irregular shapes, and so on. Do these loosely and lightly.
Come on folks, let's get the kinks out!

Now tighten them all up with a firm, smooth pencil stroke. That's it!
Now you're ready to start my class...

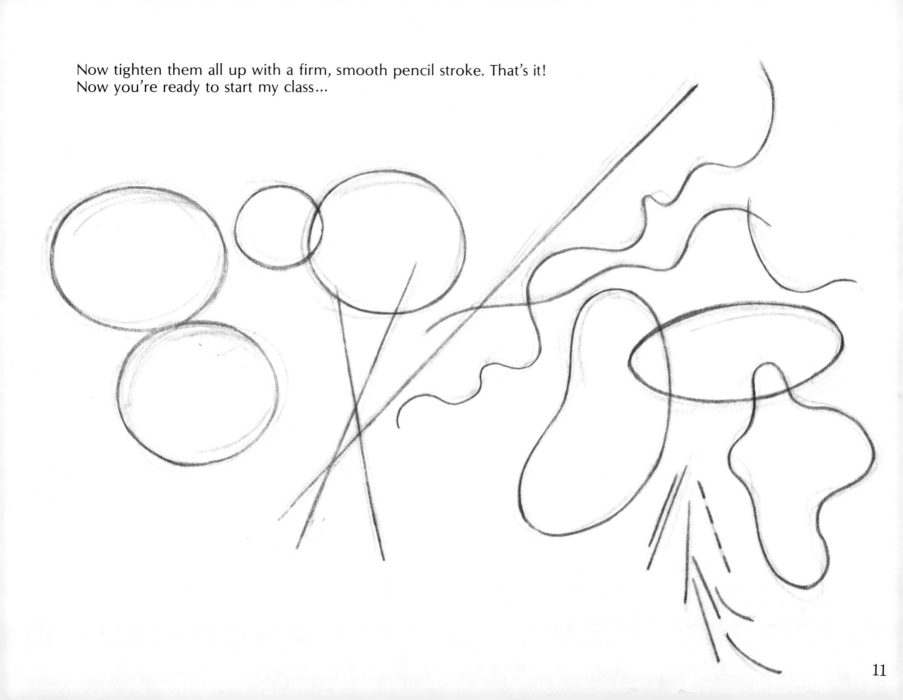

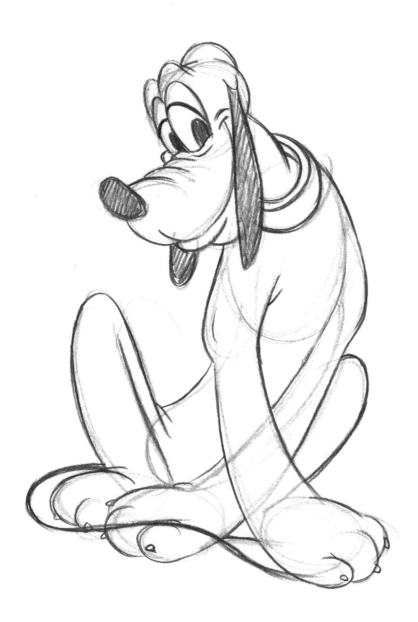

Something About Pluto

Pluto is a good-natured dog, easy going, happy and inquisitive, but not too smart. It takes him time to figure out a situation. He is nervous and sensitive—his feelings easily hurt. He's foolhardy, rather than brave. Will bark at anything strange, but will retreat hastily, if it makes a move toward him. His human qualities can be exaggerated, but in a dog-like fashion.

Hi! How about drawing some pictures of Pluto now? On the next twenty-six pages, you will learn how to draw Pluto, step by step. Remember, draw carefully and lightly until everything is just right...Then tighten it up!

1

2

3

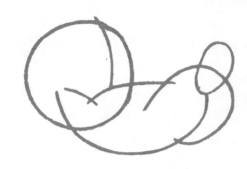

7

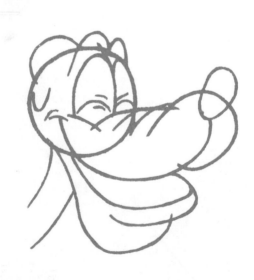

8

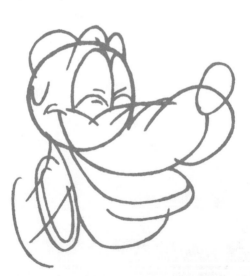

9

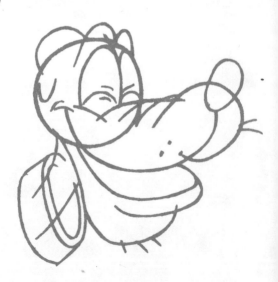

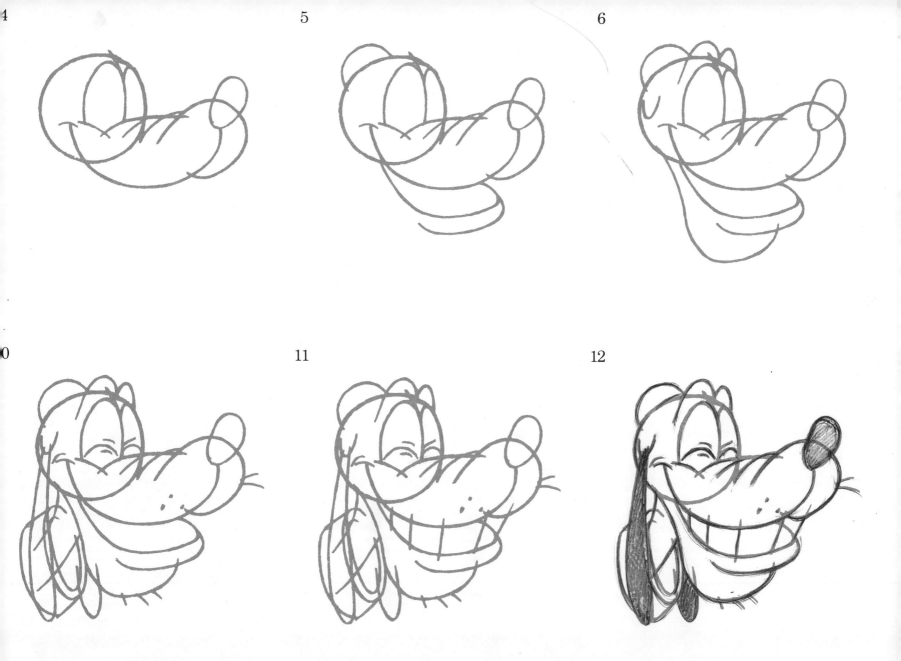

4

5

6

0

11

12

1

2

3

7

8

9

16

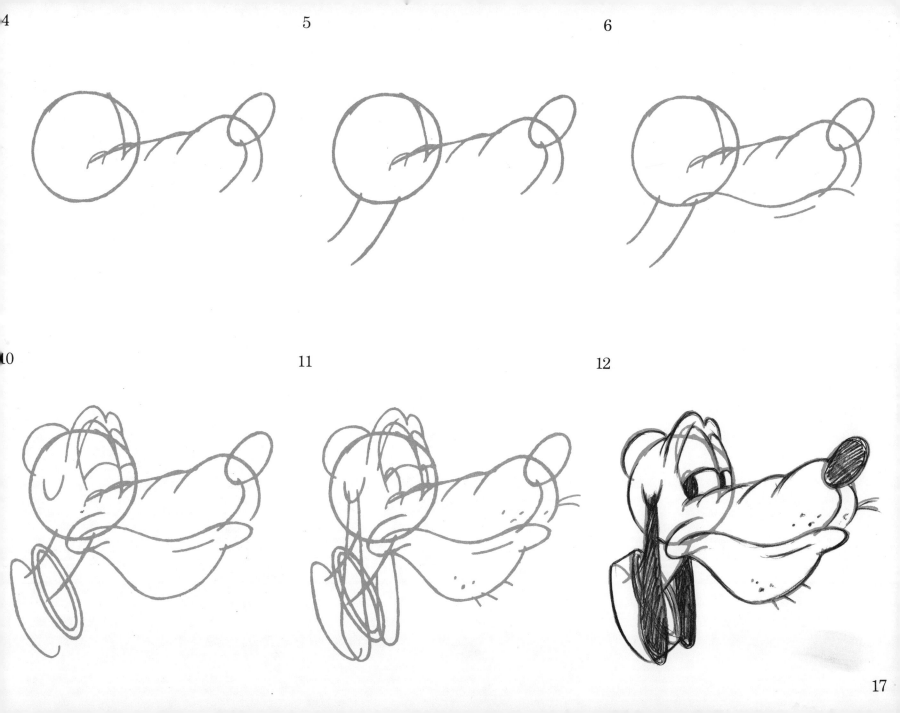

1

2

3

7

8

9

18

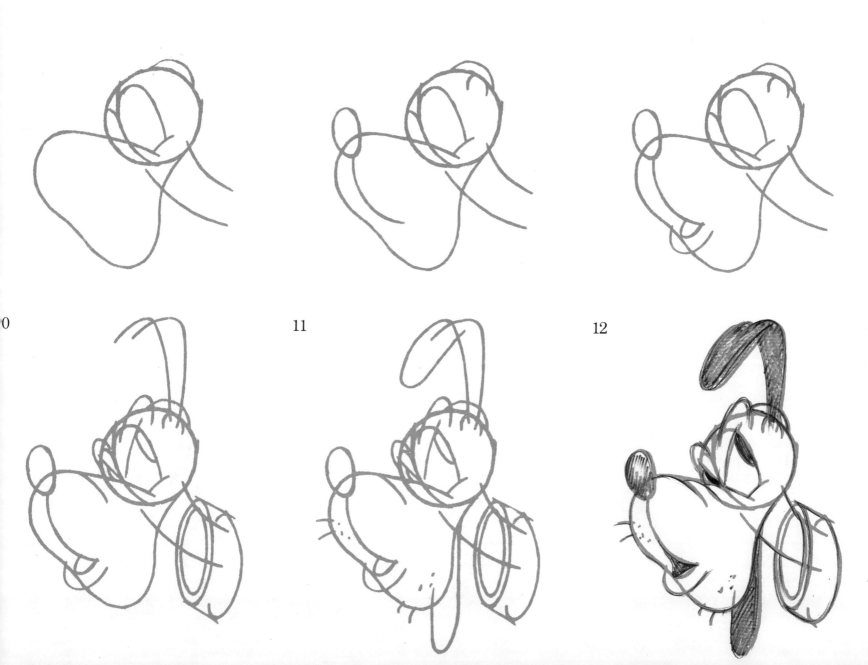

4

5

6

0

11

12

19

1

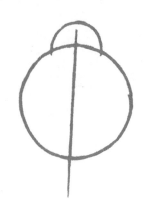

2

3

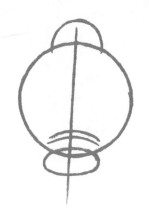

7

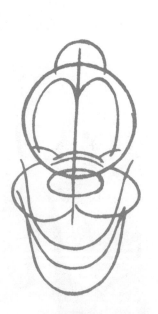

8

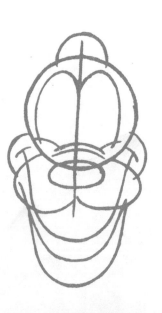

9

4

5

6

10

11

12

21

1

2

3

7

8

9

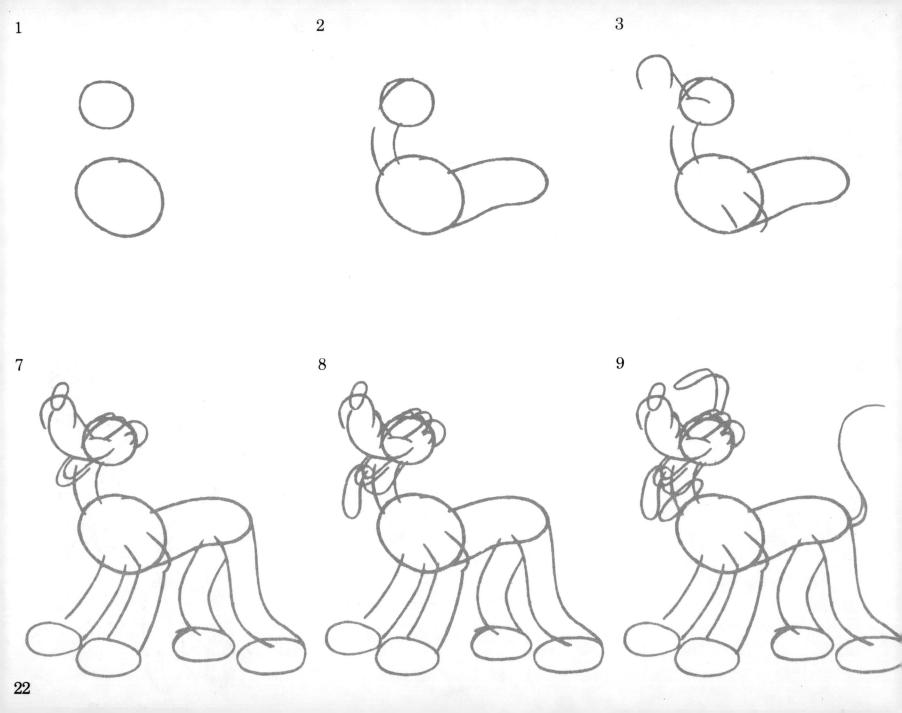

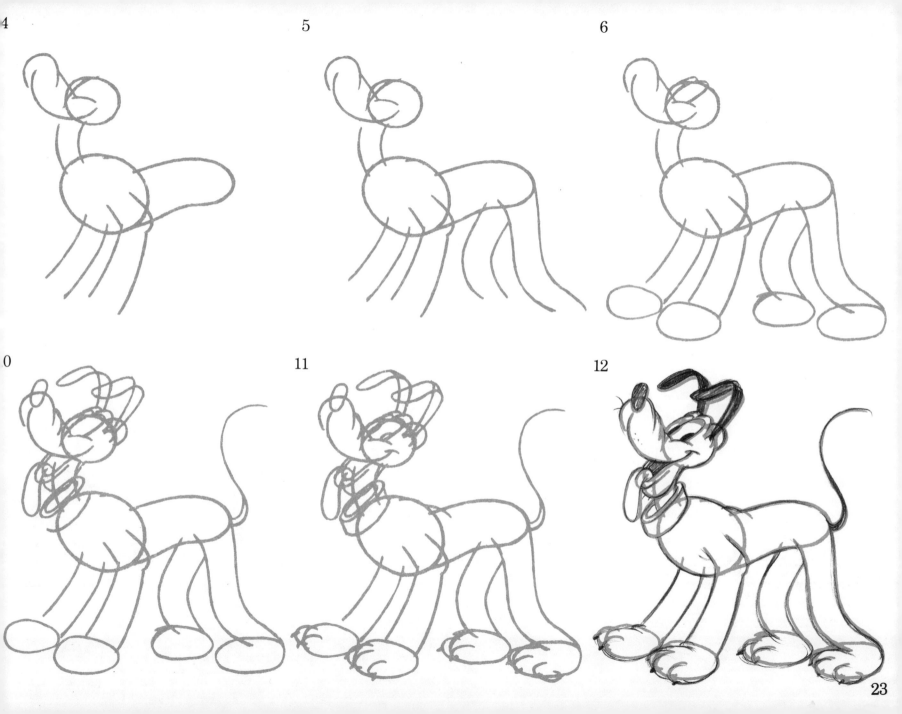

4

5

6

0

11

12

1

2

3

7

8

9

4

5

6

10

11

12

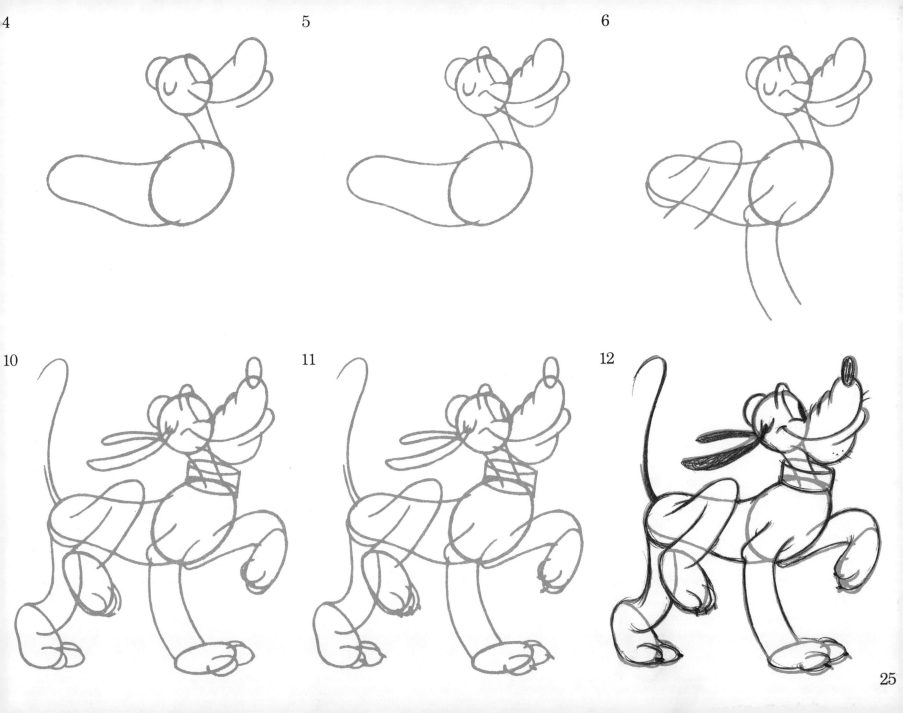

1

2

3

7

8

9

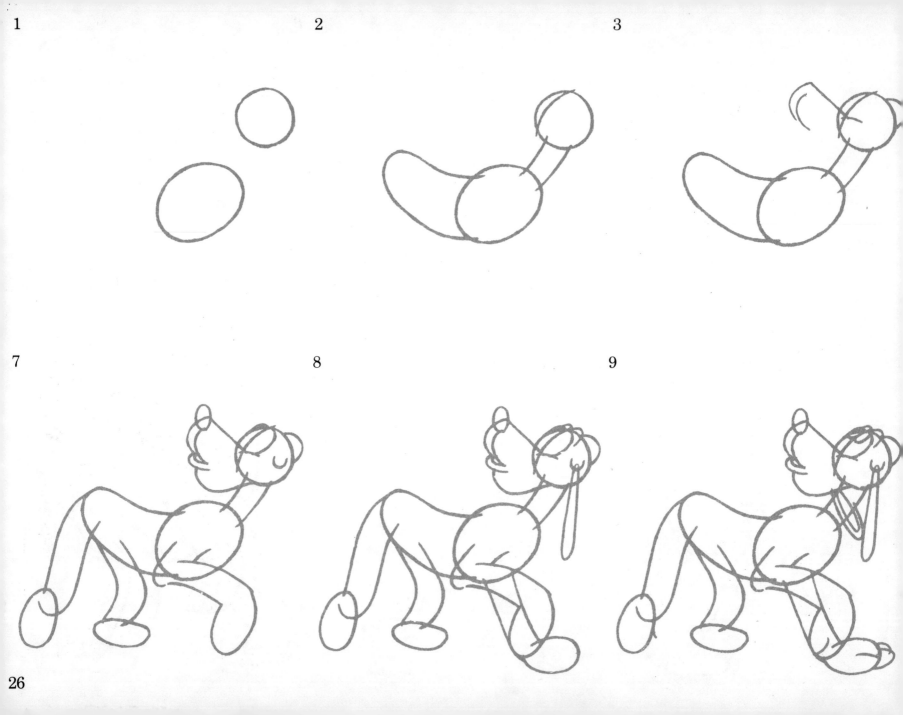

26

4

5

6

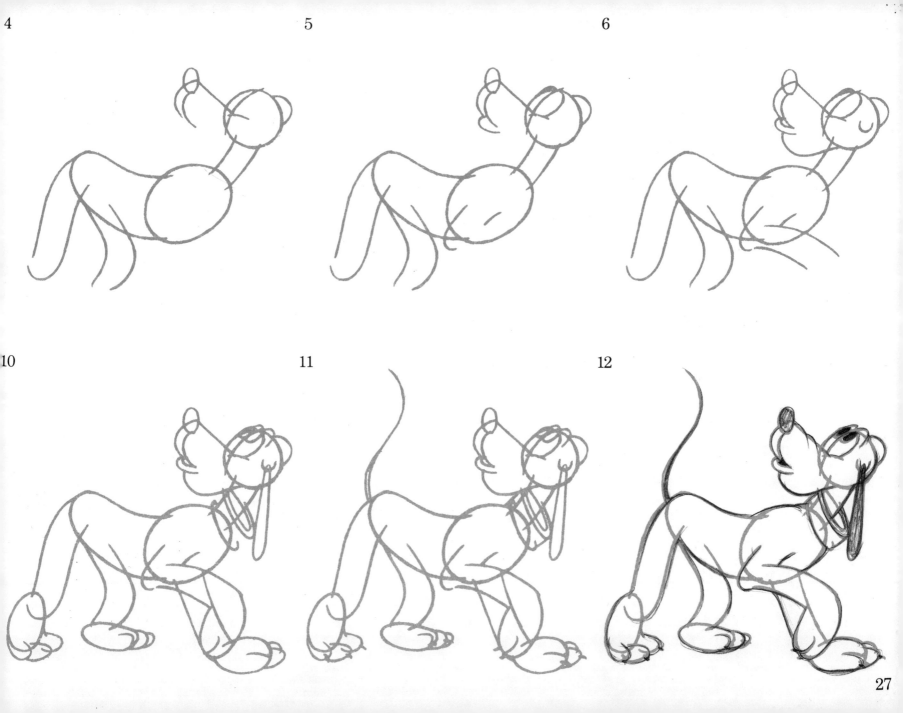

10

11

12

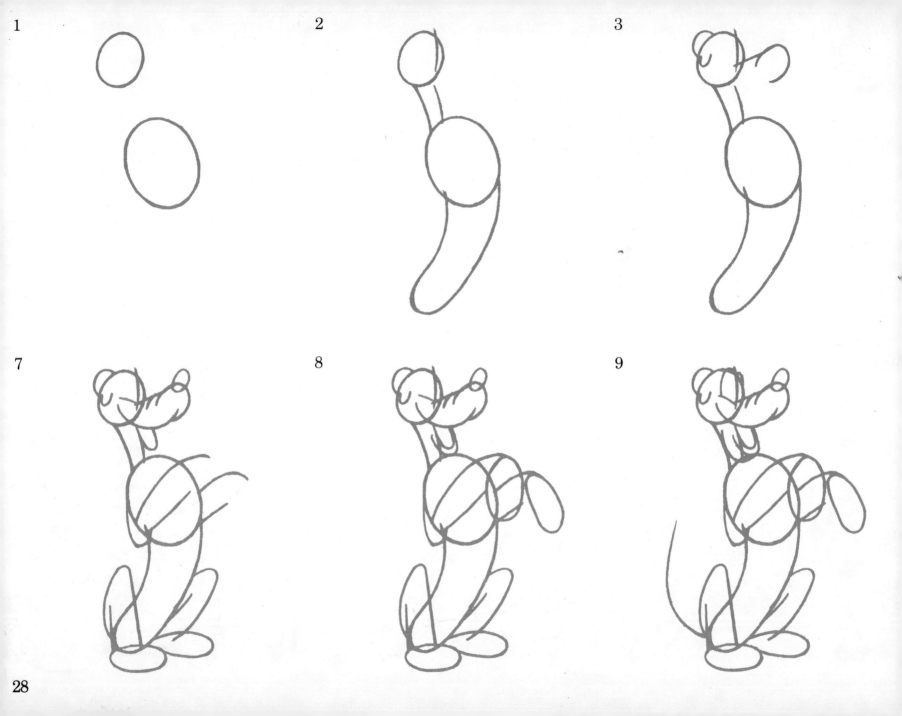

1

2

3

7

8

9

28

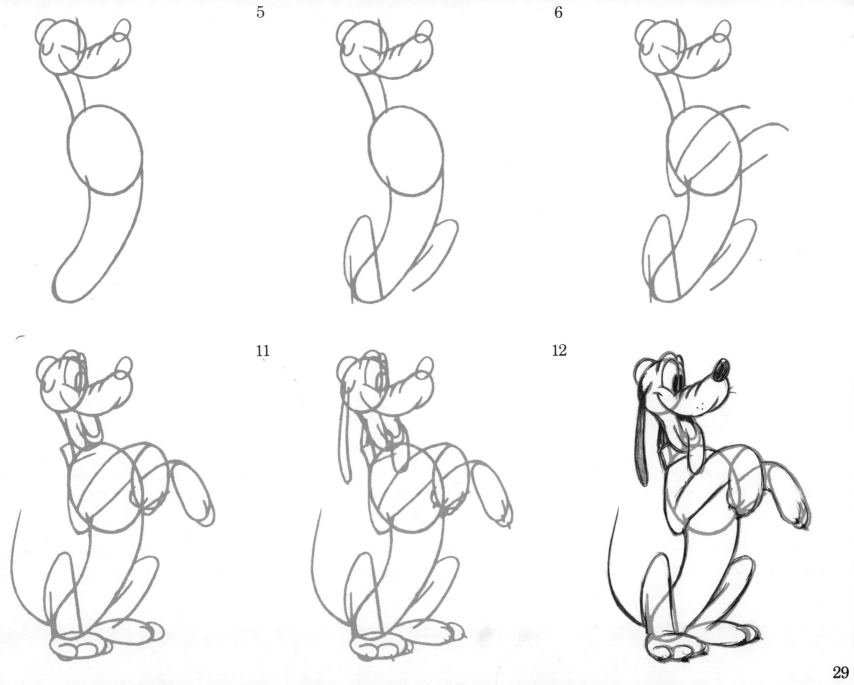

4

5

6

10

11

12

29

1

2

3

7

8

9

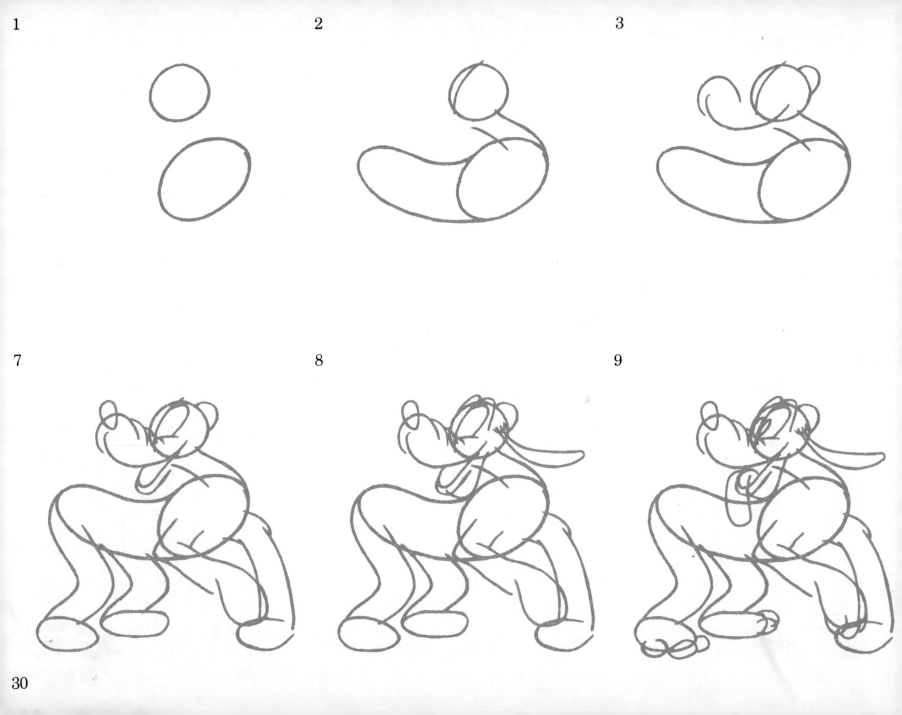

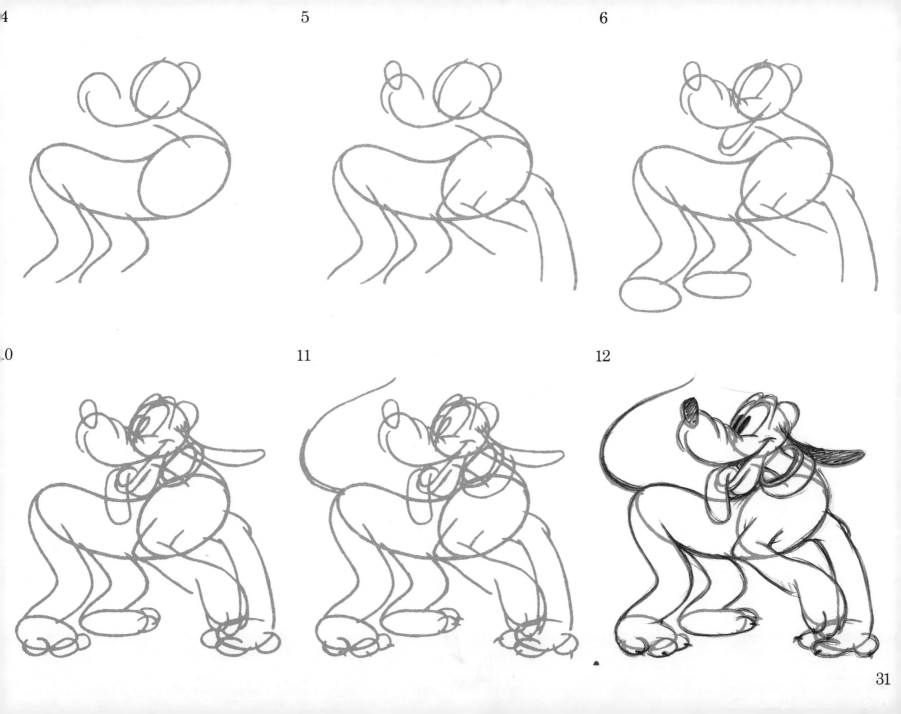

1

2

3

7

8

9

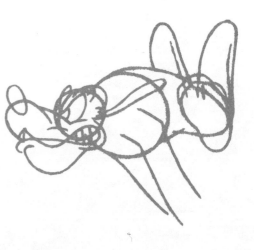

4

5

6

10

11

12

1

2

3

7

8

9

34

4

5

6

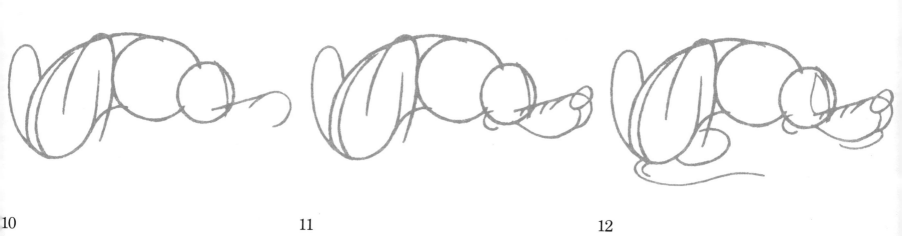

10

11

12

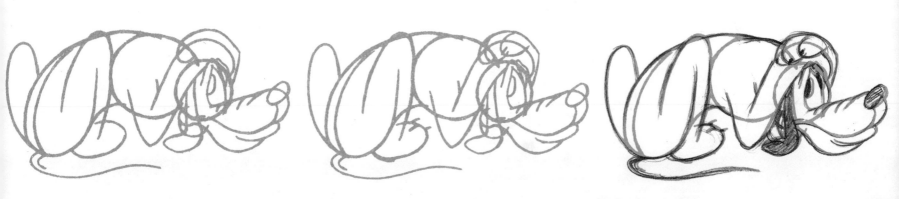

35

1

2

3

7

8

9

4

5

6

10

11

12

37

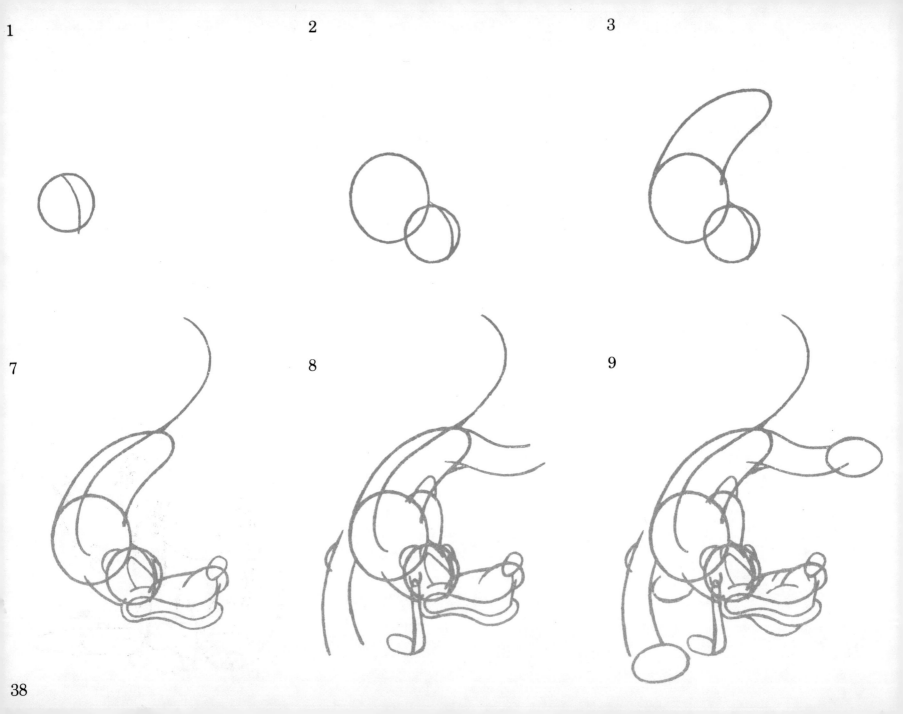

1

2

3

7

8

9

38

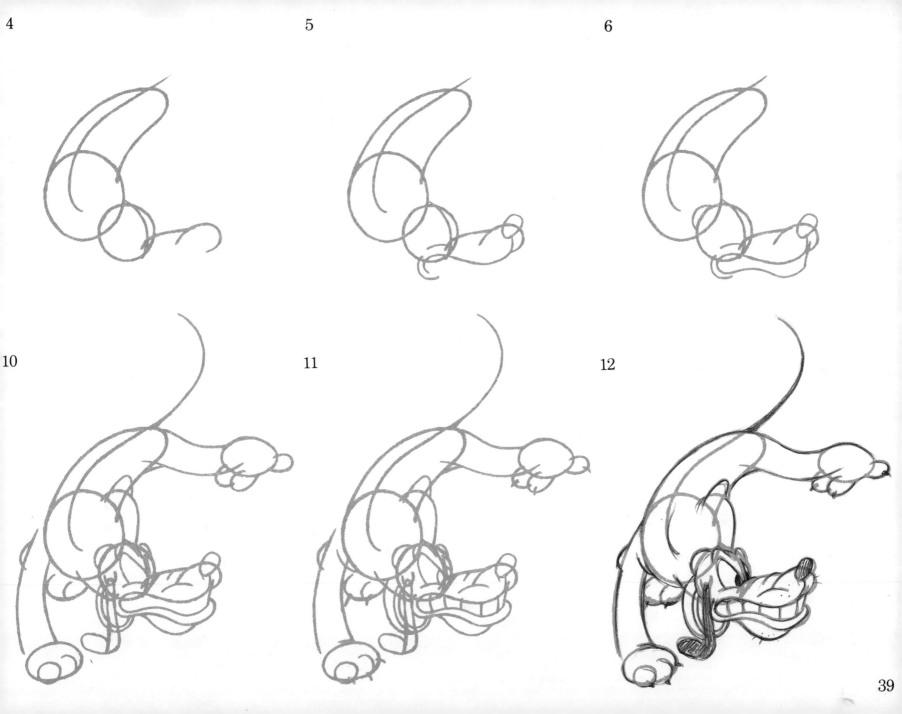

4

5

6

10

11

12

1

2

3

7

8

9

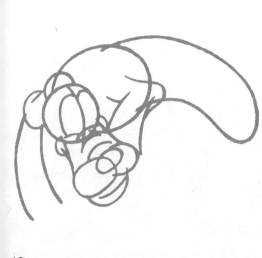

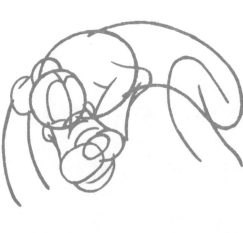

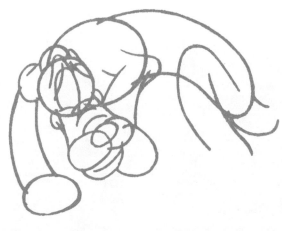

4 5 6

0 11 12

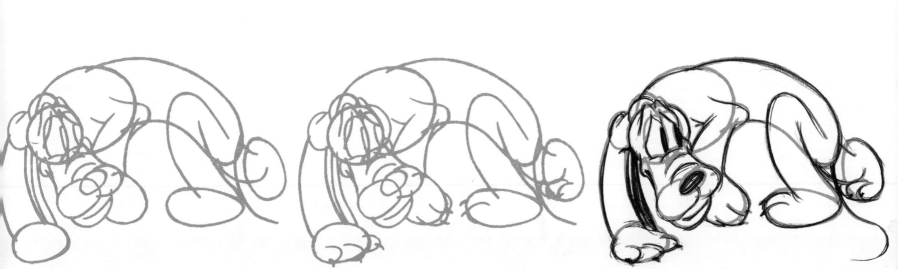

41

1

2

3

7

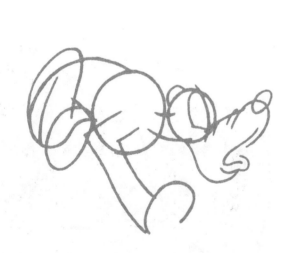

8

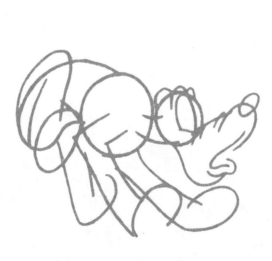

9

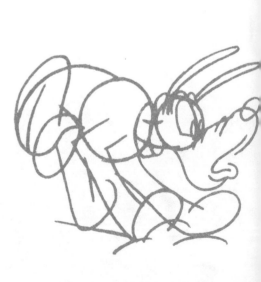

42

4

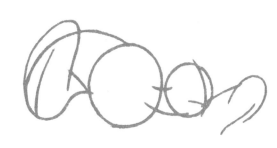

5

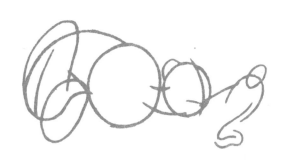

6

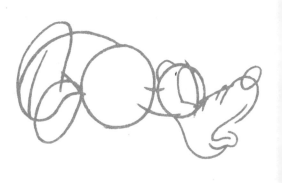

0

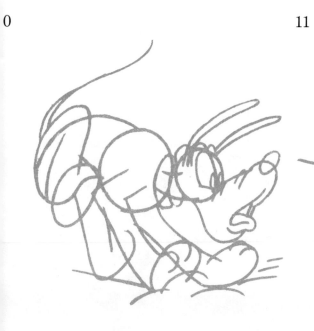

11

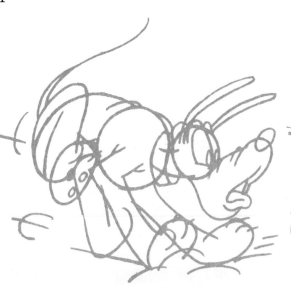

12

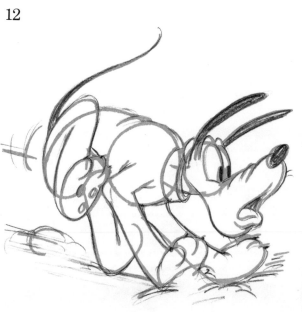

1

2

3

7

8

9

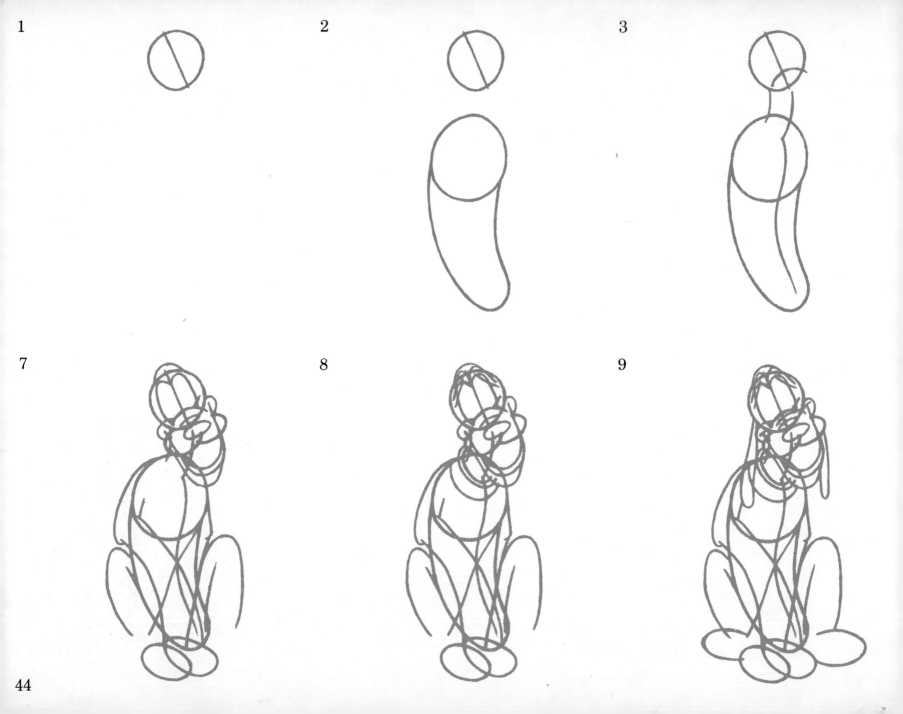

44

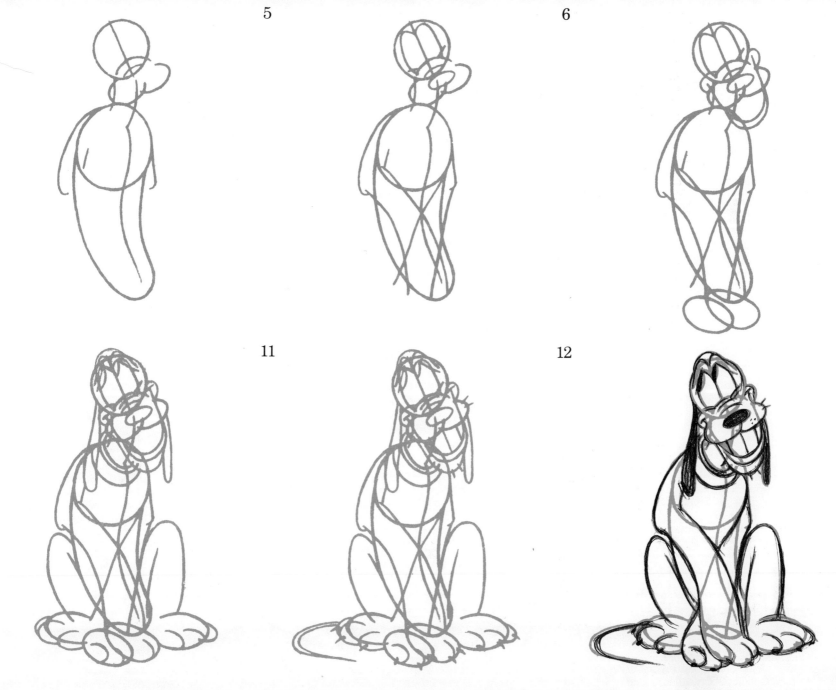

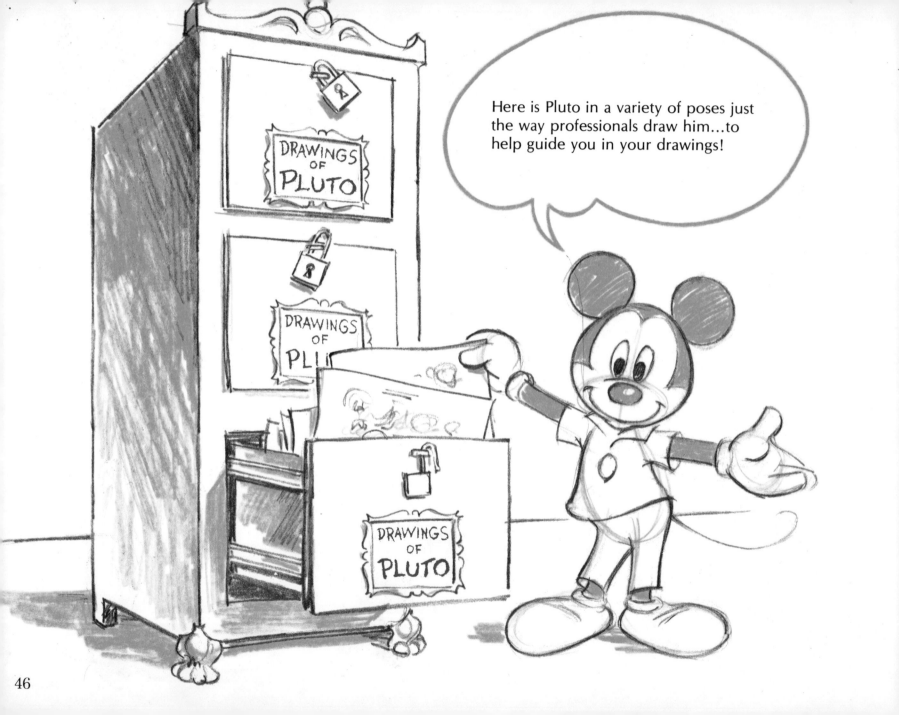

46

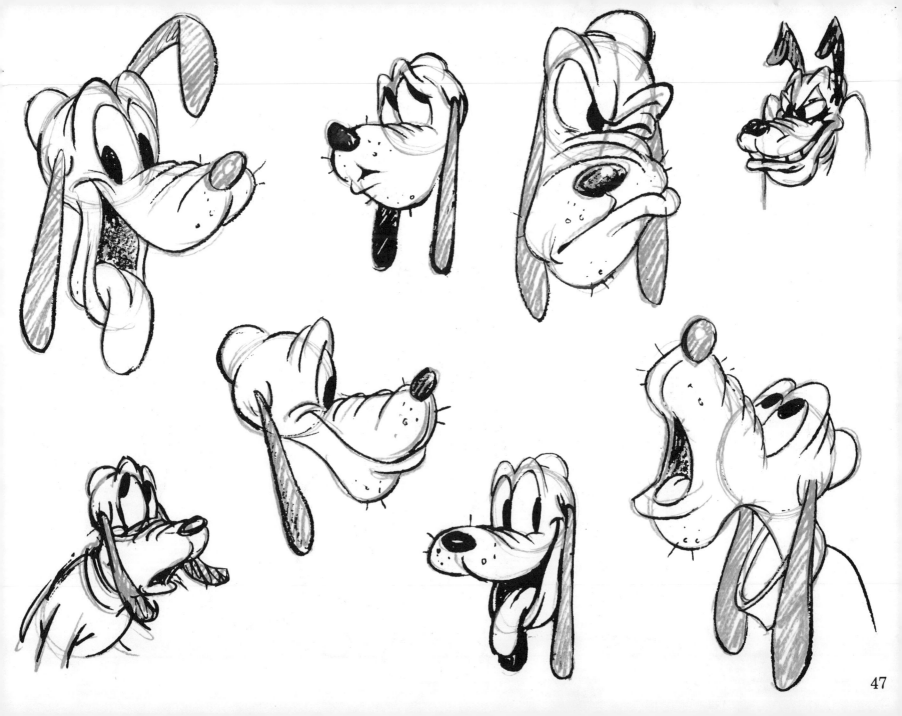

47

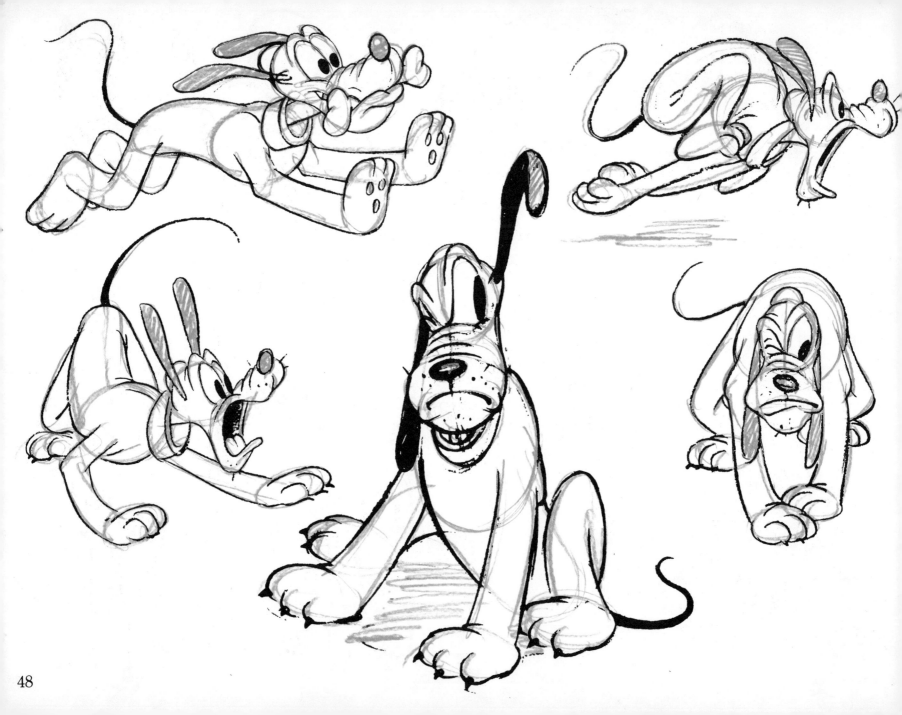

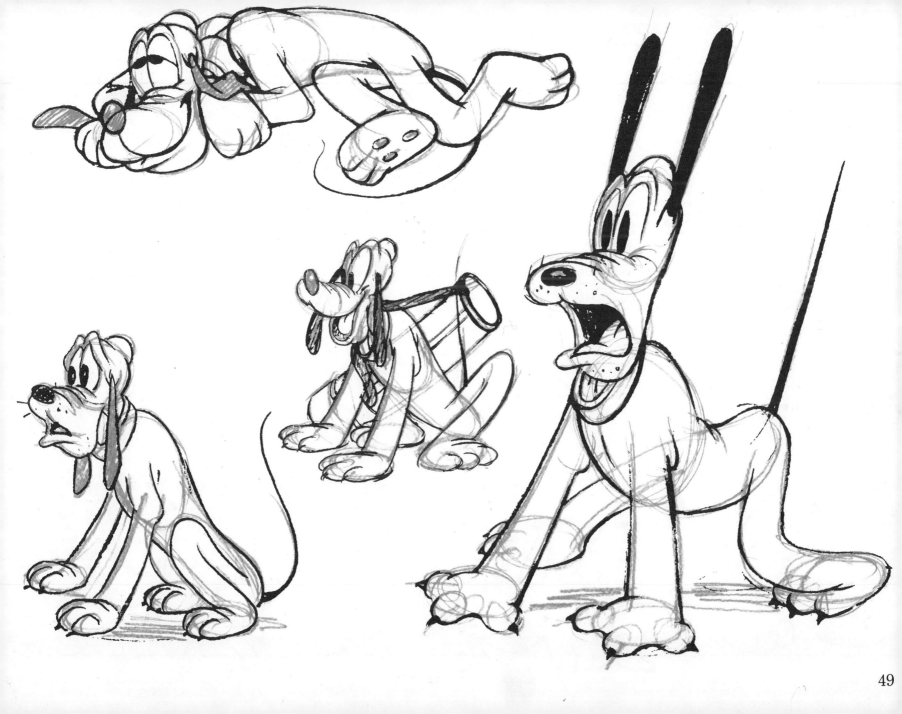

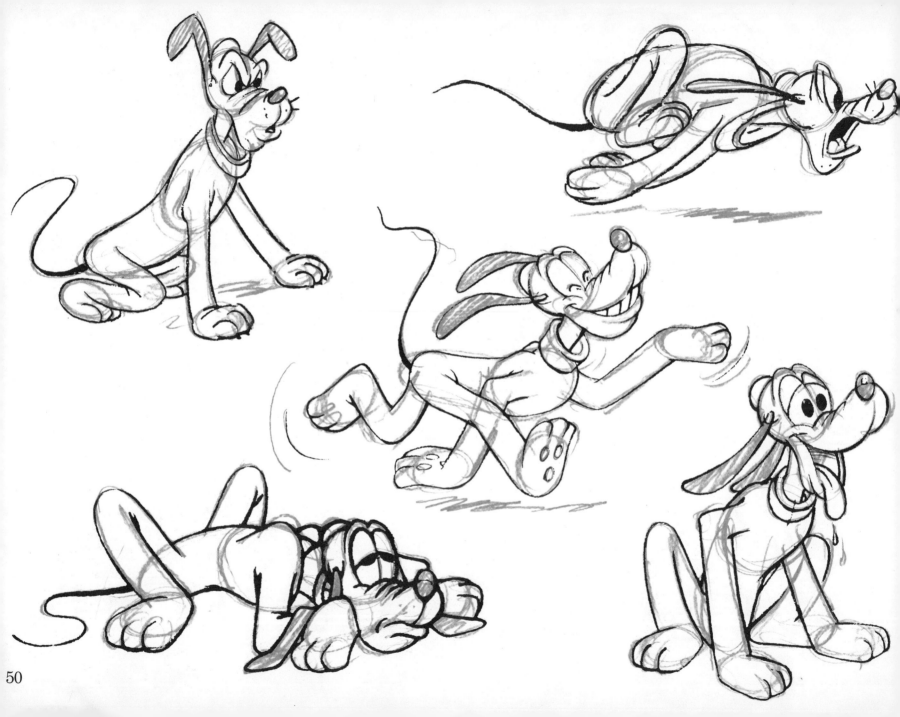

50

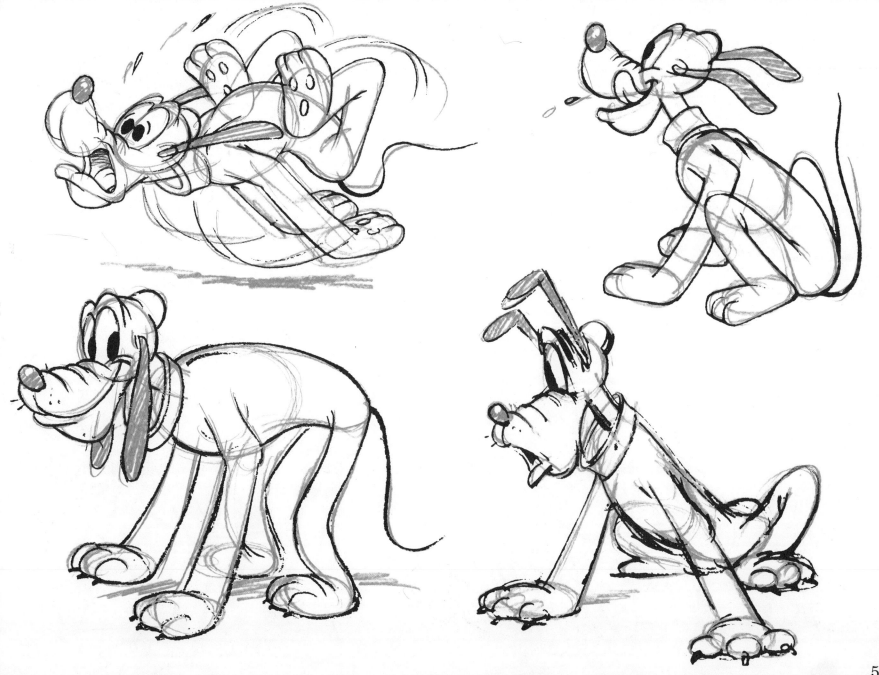

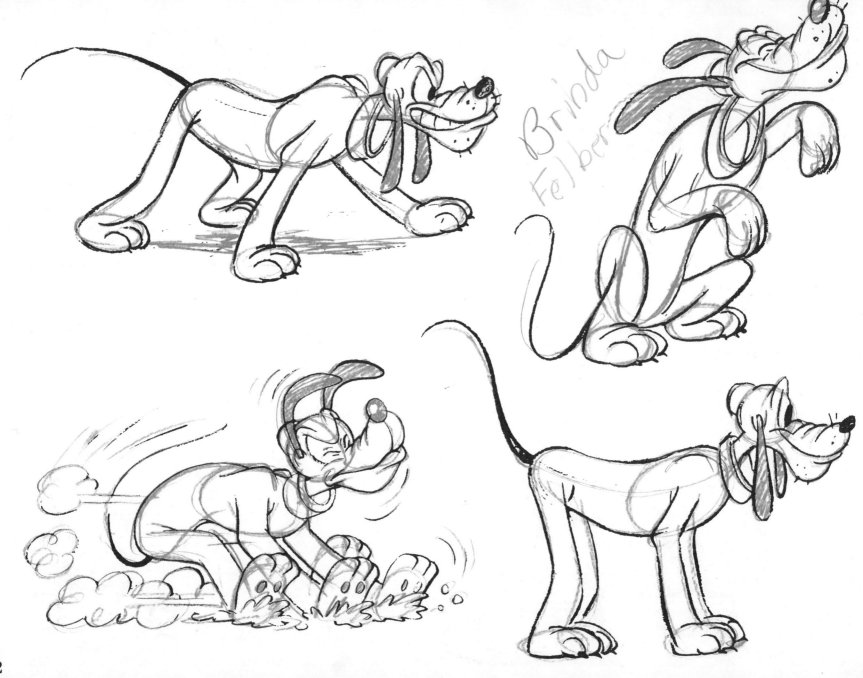

Brinda
Felber

52

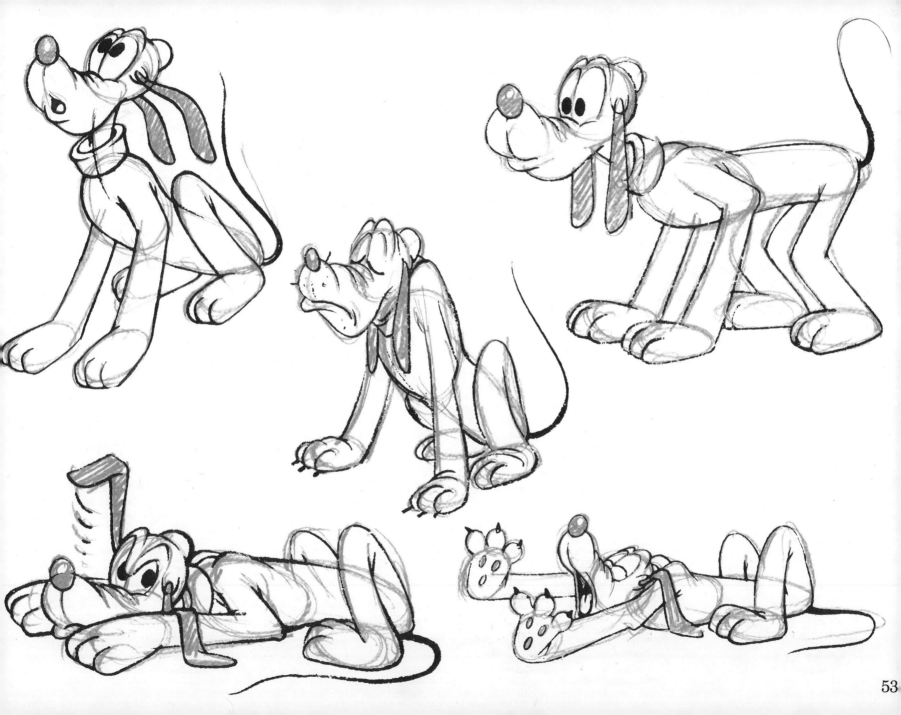

53

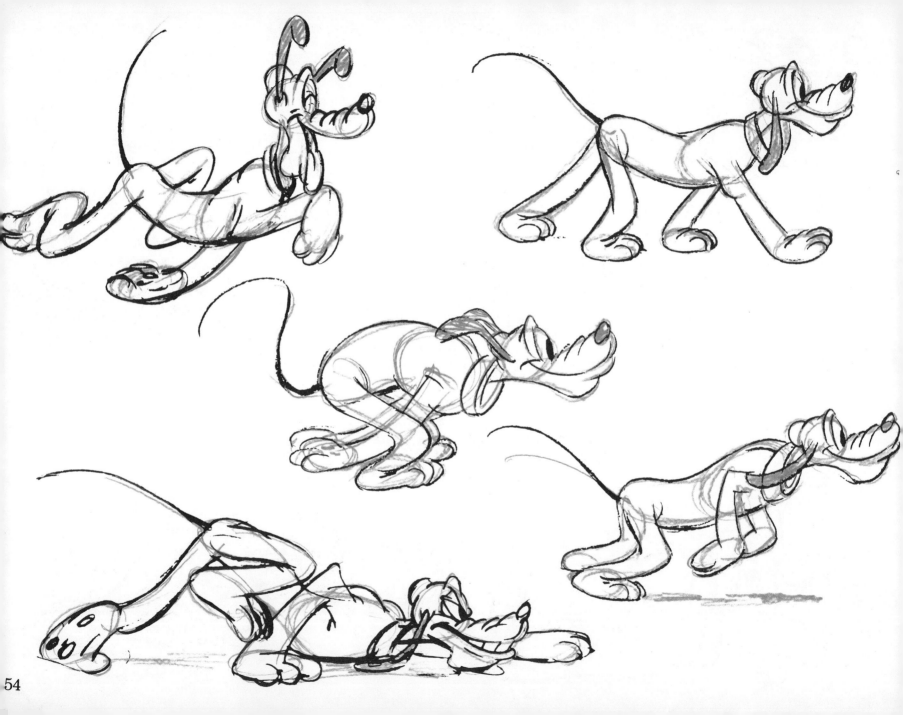

54

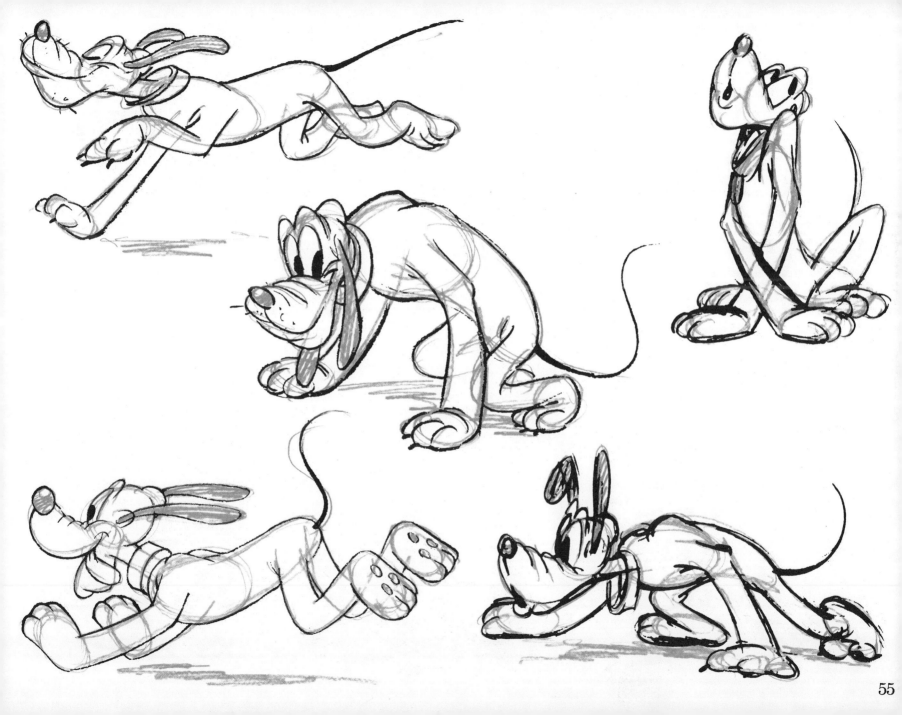

...and here's Pluto's kid brother!

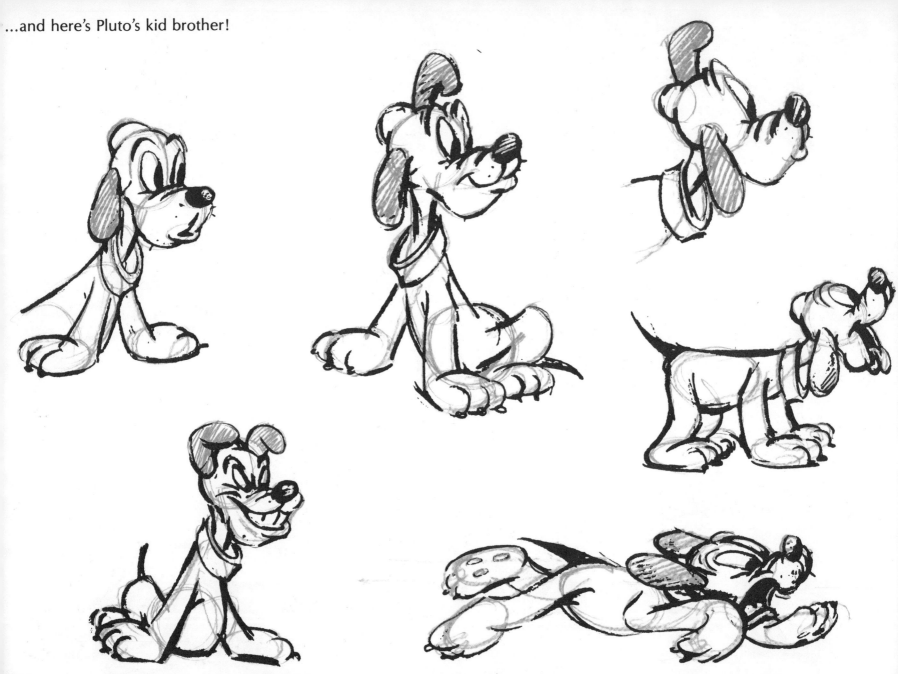

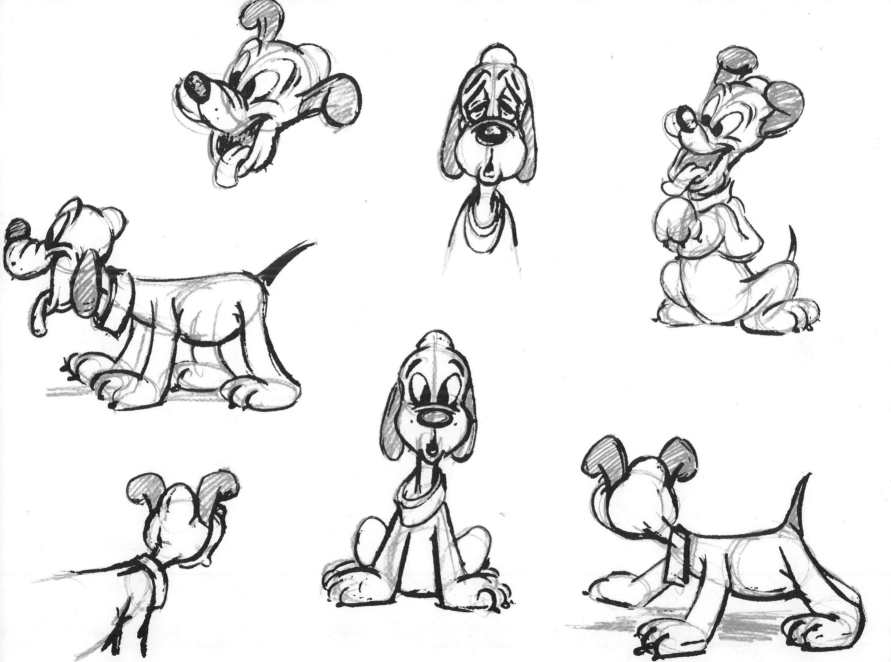

And now, here are some simple objects you can draw. If you wish, you can add them to your pictures of Pluto.

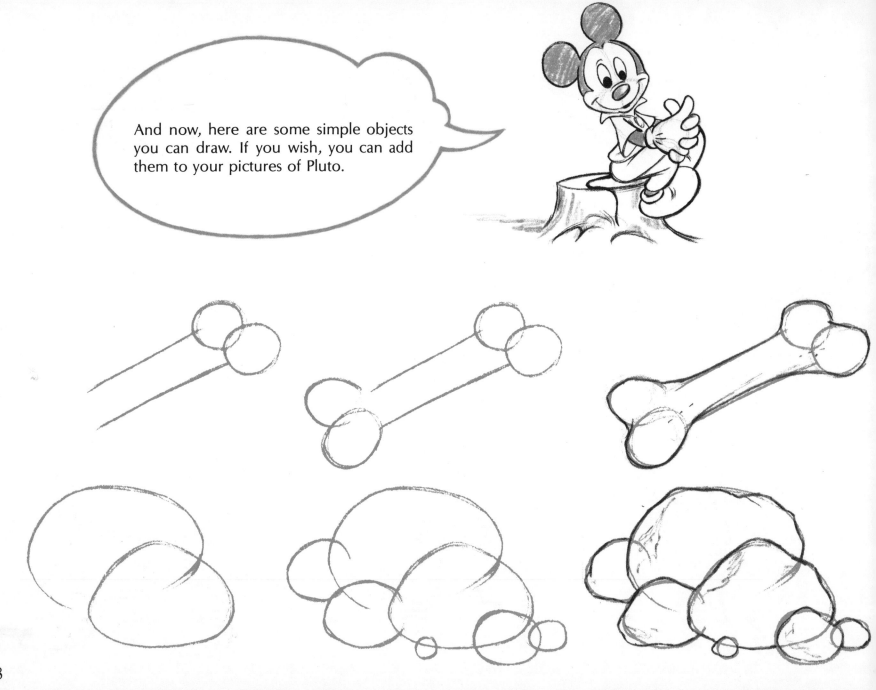

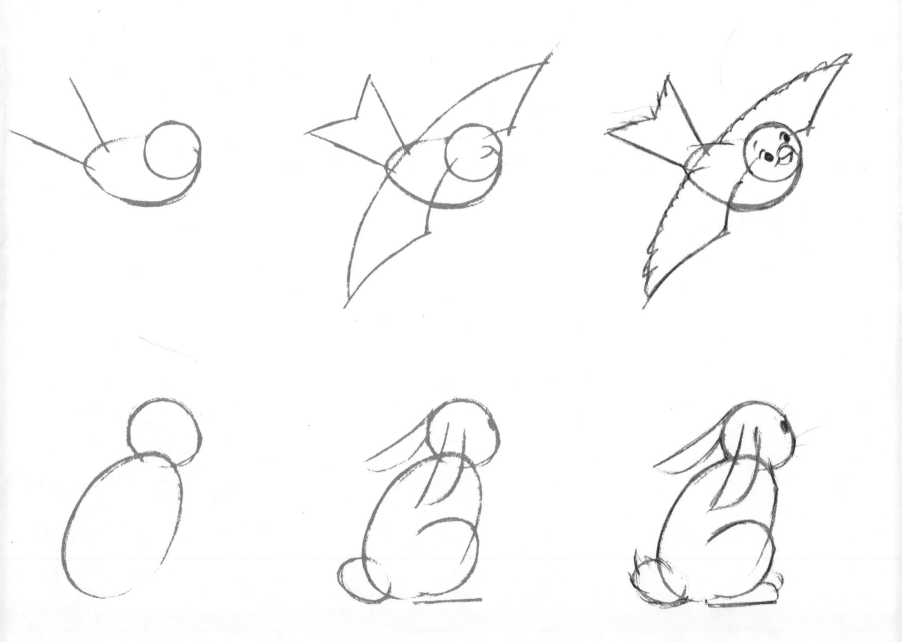

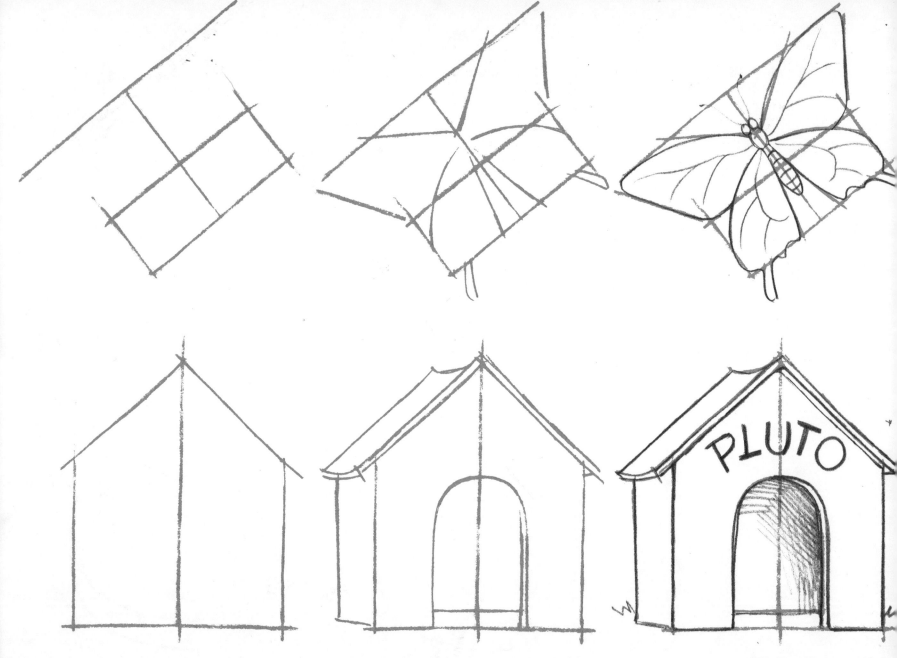

And finally, here are some simple background ideas that you may wish to use. Once you've learned to draw these, why not experiment, combining Pluto and his friends with different objects and against different backgrounds. Keep practicing and you'll get better and better and soon, who knows, you'll be able to draw your own Pluto comic strip!

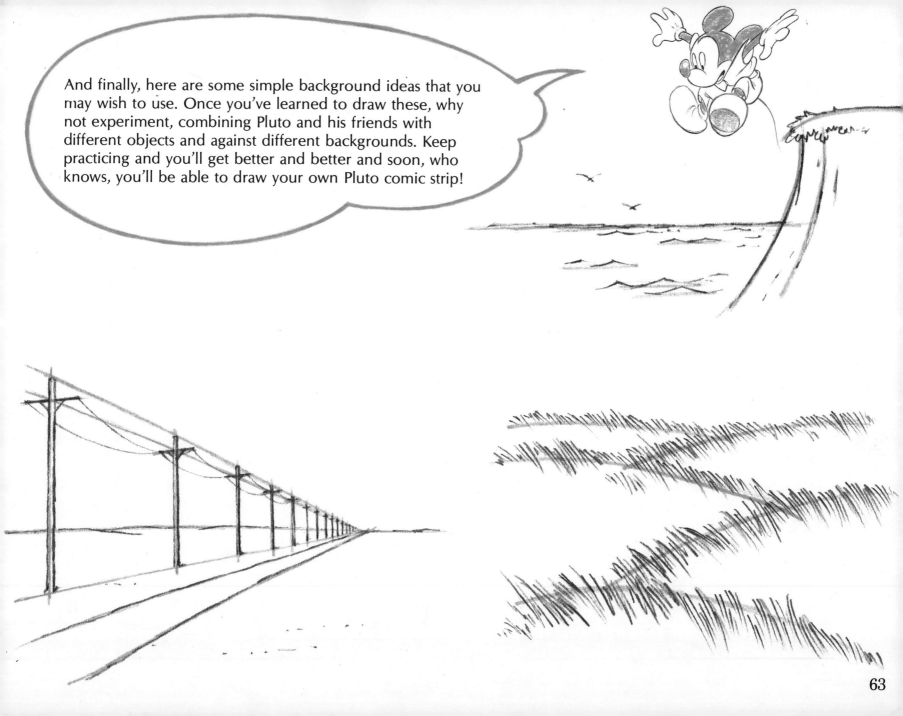

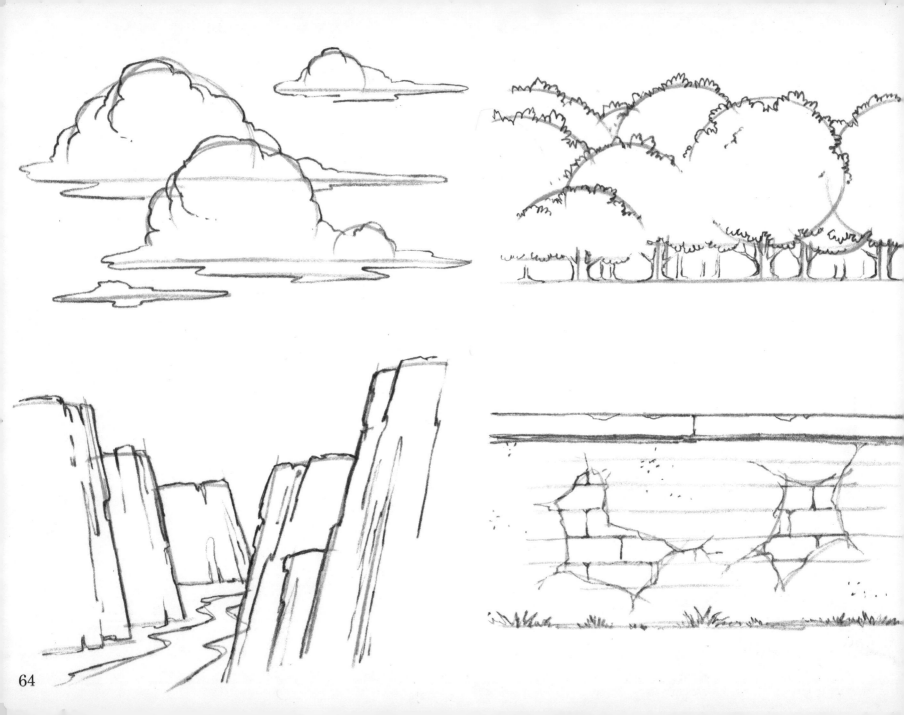